Creative Acrylic Techniques

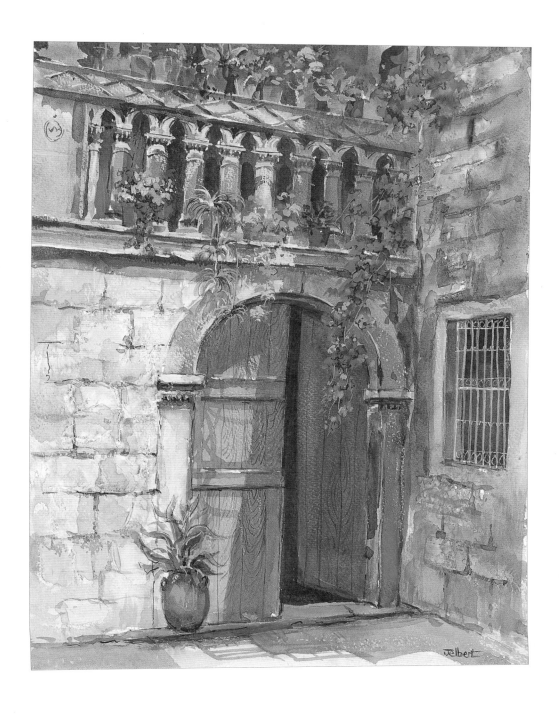

Jelbert

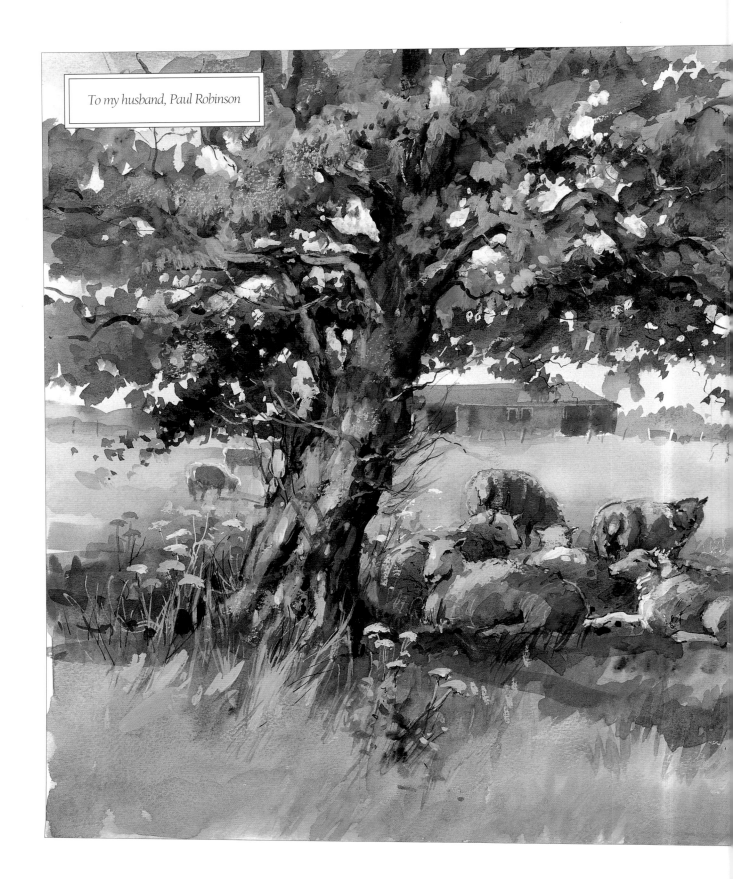

To my husband, Paul Robinson

Creative
Acrylic
Techniques

WENDY JELBERT

SEARCH PRESS

First published in Great Britain 2002

Search Press Limited
Wellwood, North Farm Road,
Tunbridge Wells, Kent TN2 3DR

Reprinted 2002 , 2003

ISBN 0 85532 848 7

The Publishers and author can accept no responsibility for any consequences arising from the information, advice or instructions given in this publication.

The publishers would like to thank Winsor & Newton for supplying many of the materials used in this book.

Suppliers
If you have difficulty in obtaining any of the materials and equipment mentioned in this book, then please visit the Search Press website for details of suppliers: www.searchpress.com

Alternatively, you can write to the Publishers at the address above, for a current list of stockists, including firms who operate a mail-order service, or you can write to Winsor & Newton requesting a list of distributors.

Winsor & Newton, UK Marketing
Whitefriars Avenue, Harrow,
Middlesex, HA3 5RH

Publishers' note All the step-by-step photographs in this book feature the author, Wendy Jelbert, demonstrating her creative acrylic techniques. No models have been used.

Printed in Spain by A. G. Elkar S. Coop. 48180 Loiu (Bizkaia)

Page 1
The Stone Balcony
Size: 285 x 405mm (11¼ x 16in)

The intricate balustrade and door details, which were highlighted with masking fluid, balance well with the acrylic texture pastes used for the walls and stonework.

Pages 2–3
Sheep in the Shade
Size: 510 x 405mm (20 x 16in)

This composition is a good example of using mixed greens which are so essential for countryside scenes such as this. The natural 'peephole' through the frame of trees, together with the difference in scale of the foreground and distant sheep, helps create depth and a feeling of space.

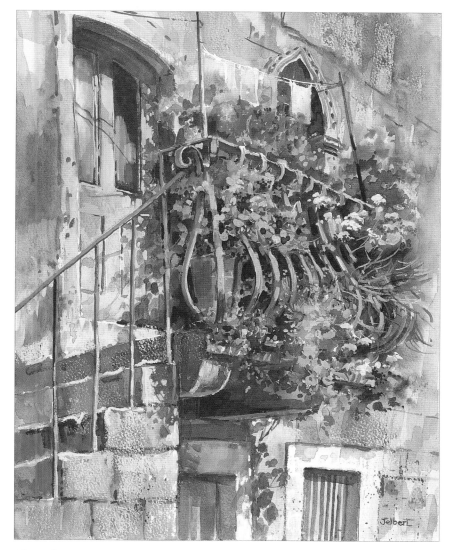

The Balcony
Size: 405 x 305mm (16 x 12in)

This beautifully adorned Italian balcony immediately caught my eye! I painted it using a combination of oil and watercolour techniques. I started the painting with an undercoat of yellow ochre to create an underlying warmth for the masonry facade. I then scumbled thicker paint for texture, and used a cream-coloured oil pastel to transform the surfaces still further and give them a weathered look. The wealth of flowers was painted wet-into-wet over an initial detailed drawing in masking fluid. I then added a few highlights and details with a pale-green pastel.

Contents

Introduction

Acrylics are, perhaps, the most versatile of all painting mediums – beginners, improvers and experienced painters all find there is no better medium. You can do virtually anything with them, which is why they are particularly favoured by the adventurous painter! Acrylics have unique characteristics, and you will enjoy them more as you get to know these special features and exploit them in your own way.

Acrylics are odour-free and water-based which makes them great for working at home or outside. They do not crack or fade, and they can be varnished (if required) on the same day you finish the painting!

Naturally, paints and additives are fully intermixable within one brand range, but my students and I have also mixed brands together without noticing any problems.

There is an extraordinary variety of additives – texture pastes and gels, matt and gloss mediums, flow enhancers, etc. – to complement a wide range of colours. Paints, which come in small and large tubes and pots, can be thick and buttery or thin and watery. Apart from standard colours, there is a gorgeous selection of fluorescent, metallic and iridescent shades, all of which are fabulous for experimental work – so you have a real treasure trove to work with!

So, where do we start? In this book I introduce you to lots of creative techniques, then show you how to apply them using exciting step-by-steps demonstrations. I have kept the projects as simple as possible; I want to encourage you to experiment and use your imagination rather than rely on a deep pocket! Mastering new techniques involves determination and lots of practice, an interaction of trial and error, taking risks with paint and materials, and some happy accidents which we all hope for in our artistic endeavours!

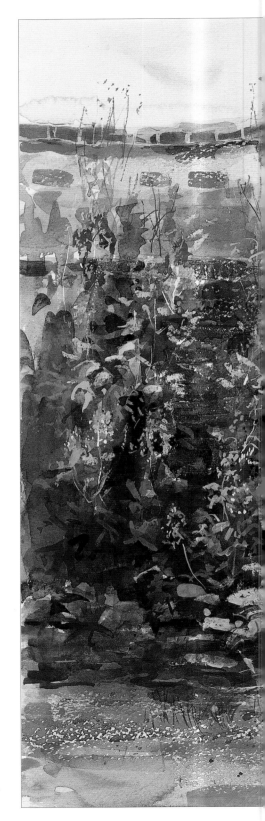

Opposite
Walled Garden
Size: 510 x 420mm (20 x 16½in)
Here I used several acrylic texture pastes and gels to enhance the weathered and aged effects on the walls, and to define the patterned bricks and stonework.

The bright foreground area and the sunlit flowers contrast with the darker tones of the wall, and entice the eye through the doorway to the garden beyond.

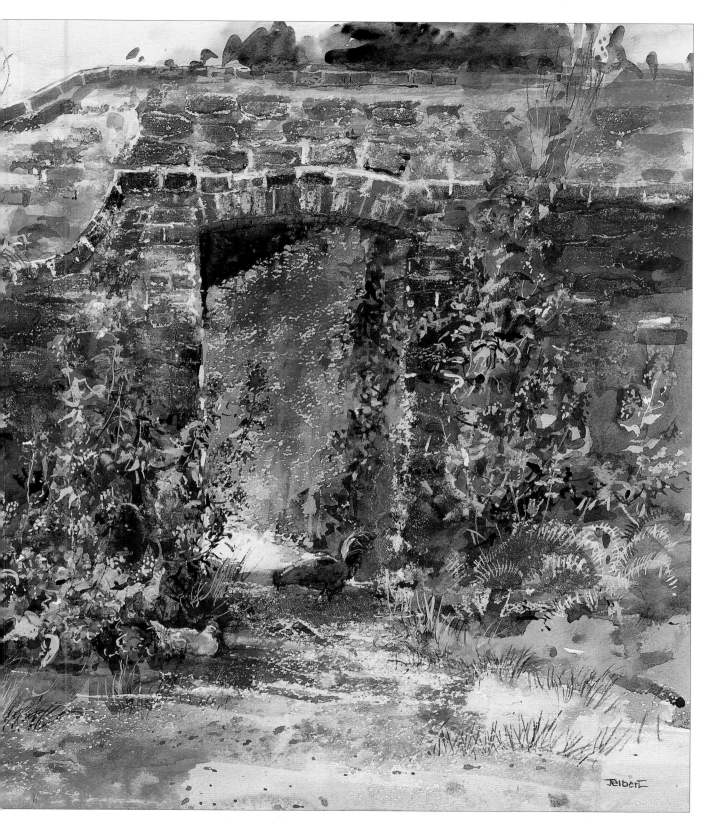

Materials

Always buy the best paints, brushes and other materials that you can afford; good quality products may cost more but, over time, they will prove far more economical than cheaper ones. On these pages, I tell you about the equipment I use when painting with acrylics.

My palette

Acrylic paints become useless if they are allowed to dry out. A 'stay-wet' palette helps preserve the dampness of acrylics so they are always ready to use. They come in a variety of shapes and sizes, most of which are ideal for studio work or painting *in-situ*.

You can make your own stay-wet palette from a shallow tray; place wetted paper towel in the tray, cover this with a sheet of greaseproof paper, squeeze the colours on to the greaseproof, then, when you stop working, stretch plastic food wrap over the tray to make it airtight.

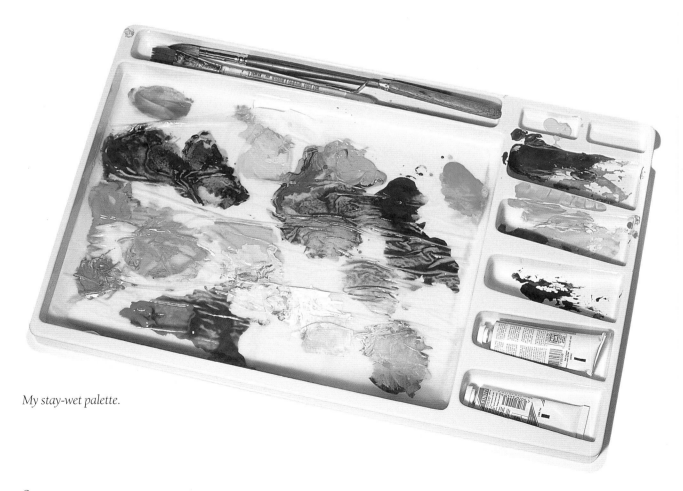

My stay-wet palette.

Colours

Artists' quality paints are purer, stronger and more true to colour than the students' quality range. Although most of my colours are artists' quality, some students' quality colours are delightful. They are often just the colour I need, so I have no problem with including them in my range of colours. Acrylic paints are available in tubes and pots. Some ranges are thin and free-flowing, others are thicker and have a buttery consistency. I use both types.

If you are new to acrylics, I suggest you begin with a starter set; these contain several small tubes and give you a good taste of what is in store! Then, as you become more experienced, you can start to add extra colours to your collection. The number of acrylic colours available grows ever larger, and is beginning to resemble the extensive ranges of oils and watercolours.

Brushes

There is quite a confusing array of brushes available. Some are designed specifically for painting with acrylics, and these include ranges with soft nylon bristles and hog hair bristles. I prefer to use my watercolour and oil brushes, but, be warned, if you allow acrylic paint to dry in a brush, you have lost it! I take care to wash all brushes thoroughly with washing-up liquid at regular intervals during a painting session.

I used just a No. 8 flat brush and a rigger for the demonstrations in this book, but I suggest that you also invest in a No. 12 flat and a couple of round brushes, say a No. 3 and No. 6.

Papers

Acrylics can be painted on virtually any surface (including clothes). However, acrylic paints react badly with oil, so **do not** paint on oil-prepared surfaces.

There is a wide variety of good pads, sheets and boards all prepared for acrylic work, with HP, Not and rough surface finishes – some have a lovely canvas-type texture.

Secure the paper to a drawing board with pins or sticky brown paper tape. Drawing boards can be made from sheets of plywood, hardboard or MDF (medium density fibreboard), and you can often get your local DIY centre to cut these to an ideal size.

Easels

There are numerous easels to choose from, made from metal, plastic and wood. Apart from the solid studio easels, you can buy table-top types and lightweight, fold-up easels. I use a medium weight, fold-up metal easel in my studio – this is easily transported to classes and is adjustable so that I can paint standing up or sitting down. I also have a much lighter telescopic, plastic-and-metal easel which I use when travelling at home and abroad. Lightweight table-top easels are excellent for working at home and can be collapsed for transport.

Other equipment

Additives, in the form of **texture gels and pastes**, are great fun to use and offer the opportunity for creating some wonderful effects. These include such ingredients as glass beads, fibres, sand and grit. There is quite a wide range available, so you talk to local art shop about their characteristics before buying them.

You can use other, less expensive materials to great effect. For example, **PVA glue** creates good watery textures, and **broken eggshells** make realistic rocks.

I also use **plastic food wrap** to conjure up beguiling abstract shapes for backgrounds, foregrounds, seascapes, flowers and woods. Working with this material needs practice, but the results are quite extraordinary and could solve a textural problem.

Different types of **salt** can be used with acrylics to create interesting textures. When salt is applied to watery acrylics, a unique series of star-like patterns and mottled markings are formed. You can use salt to create clouds, foam on rocks, snow flurries and massed foliage – experiment and I am sure you will be able invent some other ideas.

A plastic or metal **palette knife** is best for applying texture gels and pastes, and for impasto work. A **sponge** is good for both applying and lifting out colour.

I use **masking fluid** to create highlights. For fine work I find it best to dilute neat masking fluid with up to 15% water. I also like to add a touch of colour so I can see it more clearly on the paper. I prefer to apply masking fluid with

a ruling/drawing pen; old brushes could be used but I find these too clumsy and they do not hold the reservoir of fluid needed in delicate preparations.

I love using **aquarelle pencils** for my initial drawings, as they also can be used to form tonal washes if I need more detailed work. I choose a colour that is compatible with those in the finished painting. I also use a 3B, 4B or 6B grade **graphite pencil** for general sketching.

A roll of **paper towel** is very useful for lifting out colour and for general cleaning up.

I use a very soft **putty eraser** to correct my pencil sketches.

I use strips of **sticky brown paper tape** to secure the paper to my painting board.

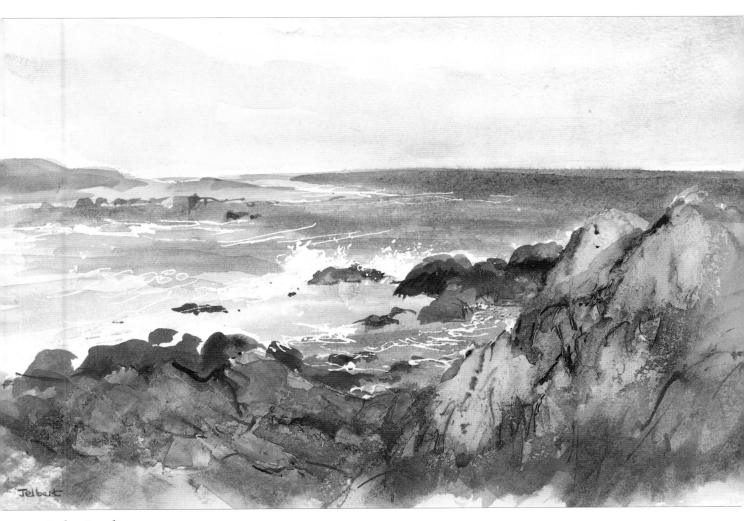

Rocky Coastline

Size: 330 x 215mm (13 x 8½in)

I started this seascape by applying masking fluid in the sea area to create highlights on the water surface and the spray on the rocks in the middle distance. I then applied a sandy texture paste over the rocky foreground before completing the painting with watery acrylic washes.

Easy colour mixing

Colour mixing is one of the basic techniques of painting, and producing a range of accurate and predictable colours needs continual practice. Without a knowledge of how colours mix and match, you will be searching continually for that elusive shade that can never be found in a ready-mixed tube of paint.

Primary and secondary colours

We all know that mixing pairs of primary colours (red, blue and yellow) together produces the secondary colours purple, green and orange, and that mixing a primary colour with a neighbouring secondary colour will produce six tertiary colours. However, this is a simple interpretation of a rather complex subject, in that the secondary and tertiary colours will depend on the hue of the primary colours. We all see colours differently, so playing with your range of colours is the only way to build knowledge. The most important factor about mixing colours is to place the dominant colour in your palette first, then slowly add small amounts of the other colour until the right shade is reached.

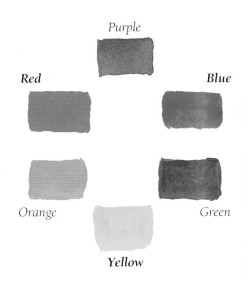

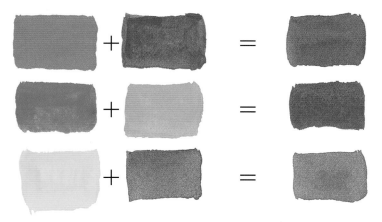

Mixing complementary colours together produces a range of mid-tones.

Complementary colours

Complementary colours are those that are opposite each other on the colour wheel: red and green; blue and orange; and yellow and purple. These colours are very important as they can make a painting vibrate. Placing complementary colours near each other in a painting creates a visual reaction that makes the whole surface more exciting. Study the work of successful artists and you will soon discover how cunningly these complementary tactics can be used! A simple example is a bowl of green apples. On their own they could look rather dull, but if you replace a green apple with a red one, or place all the green apples in a red bowl, the composition becomes visually more exciting.

When you mix pairs of complementary colours together, they dull and neutralise each other, and create a range of mid-tone hues that can be very useful in a painting.

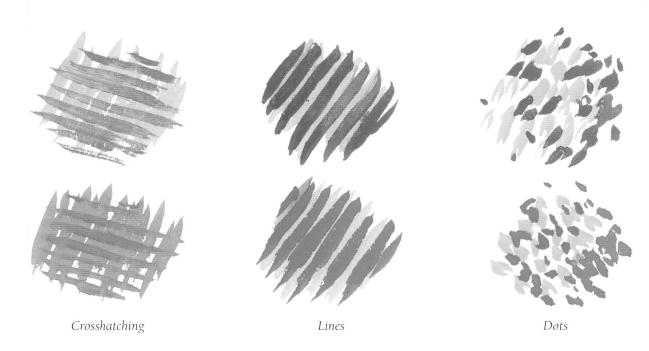

Crosshatching *Lines* *Dots*

Mixing colours

Colours can be mixed in different ways. For example, the orange shown on the colour wheel opposite was created by mixing red and yellow on the palette; this mixture was then painted on the paper. Another way to achieve this colour is to 'mix' it on the paper by laying in the primary colours as dots, lines or crosshatching. When the painting is viewed from the correct distance, the individual colours merge together – the great impressionist painters used these methods and techniques to great effect.

Greys

Another set of useful colours are the greys. Everyone needs these at some time or other, either to contrast a brightly coloured area or, perhaps, to create an atmospheric effect.

This illustration shows three of my favourite grey mixes. Each combination of two colours produces a different range of grey tones; by adding a little more or a little less of one colour you can vary the intensity, warmth or coolness of the grey. I used cerulean blue in the first mix, but you should also experiment with ultramarine or cobalt blue.

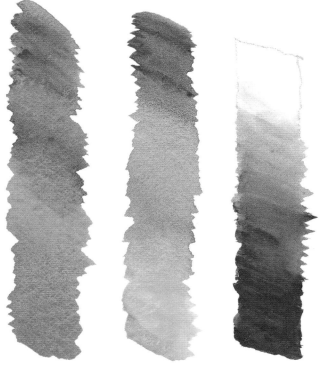

Cerulean blue with burnt sienna *Yellow ochre with dark purple* *Payne's gray with white*

13

Enjoying your greens

When looking at nature, I am always astounded by the complexity and variation of the greens, and that nothing seems to clash or look wrong! However, when we try mixing these greens ourselves, we often produce colours that completely destroy a picture that would otherwise have been a reasonable effort! The secret, in my opinion, is to keep the mixing process as simple as possible, and to use different tones of just one green – one of the ready-mixed greens or one mixed from yellow and blue. Using only one basic colour gives unity to the finished work.

The ready-mixed greens shown above right are my particularly favourites. They produce some good-looking and convincing greens and, by just adding more water, you can soften and lighten them to make a wide range of tones.

I used a ready-mixed, light olive green as the starting colour for all the greens depicted in the painting on page 15. This green was darkened, cooled, softened and warmed as needed, by mixing it with other colours.

I know I am repeating myself, but do experiment with your own mixes – it is so important – it is the only way to get to grips with reproducing all those glorious colours that nature provides!

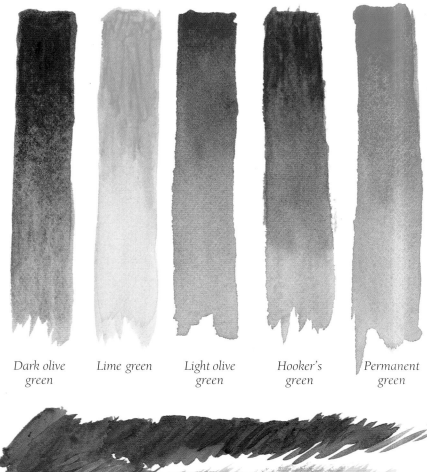

Dark olive green *Lime green* *Light olive green* *Hooker's green* *Permanent green*

Most of the colours used in the painting opposite are shown here. The basic green is light olive green into which I mixed (from top to bottom): deep purple, for the darks; cadmium yellow, for the sunlit areas; cerulean blue, for the shaded foliage; and burnt sienna, for the more subdued but warm tangles of garden greenery.

Opposite
The Quiet Retreat
Size: 305 x 385mm (12 x 15in)
This was a demonstration piece for my students to show them the abundance of textures and shapes, and the wide range of greens that can be found in a garden scene.

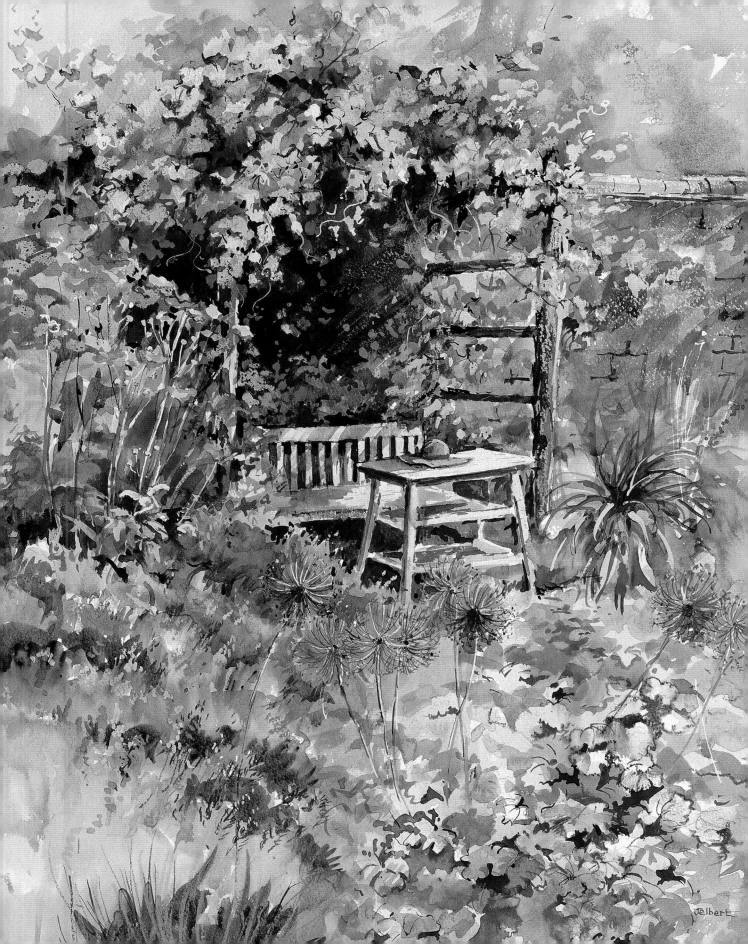

Painting techniques

Acrylic paints are very versatile: they can be diluted and worked to give an appearance similar to that of watercolours, or they can be applied much thicker to resemble oils. On these pages, I show you some of the many techniques that can be used with acrylics. This diversity of application requires practice, and care should be taken to match the method with the subject matter.

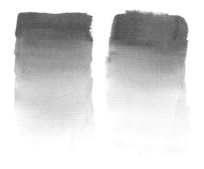

Gradated washes, wet on dry (left) and wet on wet are easy to achieve with acrylics. I applied fairly neat colour first, then gradually added more water to the wash as I worked down the paper.

Blended washes such as these are ideal for skies, but they need lots of practice to master. They can be worked wet on dry (left) or wet on wet.

Acrylics are translucent enough to allow one colour to be glazed across another. Here, I painted vertical stripes of blue, red and yellow, then, when these were dry, I glazed three horizontal stripes of the same colours on top.

Acrylics can be applied wet into wet in exactly the same way as watercolours. Here, I wetted the paper, dropped in spots of red, then let these merge and spread across the paper.

The wet-into-wet technique also works well with multiple colours. Here, I dropped spots of red, blue and yellow on wetted paper, then tilted the paper back and forth, and side to side, to allow the colours to mix and blend together. A super abstract start to a picture!

Lifting out is another watercolour technique that can be used with acrylics. Here, I applied a wash to the paper, then used pieces of dampened paper towel to lift out small areas of colour.

I use masking fluid to create highlights and intricate shapes. I applied it with a ruling pen, left it to dry, then painted a wash over the marks. When this was completely dry, I removed the masking fluid to reveal the white of the paper.

Acrylics can be applied with a palette knife as with oils. Here, I used colour straight from the tube, knifed it into an impasto, then dragged some of the colour dryly over the surface.

Here, I brushed a base layer of neat blue on the paper. When this was dry, I used a palette knife to apply neat yellow, leaving some quite thick and spreading other parts thinly to create blurred shapes with some of the blue showing through.

This technique is unique to acrylics, and can be used to great effect. I applied various colours to the paper; some quite thickly, others as washes, then allowed the paint to become slightly dry. I then placed the paper under running water and rubbed the surface with my fingers to wash away some of the colour. The result is an abstract, partly painted under-picture ready to be re-focused and completed.

Salt can be very beguiling when used with acrylics – just as it is with watercolour washes. Having laid a wash of acrylic, I immediately sprinkled salt over it then left it to react chemically with the paint.

Gorgeous effects can be created with sponges. Try out several different types of sponge with various thicknesses of paint. Layers of sponged colours can add a fragile and alluring depth to subjects such as trees and shrubs.

Spattering is a technique that I use to create random spots of colour. Here, I have dampened the bottom part of the paper, then spattered an acrylic wash all over. I create the spattering by drawing a loaded brush across my finger (see also page 37).

Creating texture

Acrylics are extremely adaptable, with a wonderful untamed quality which lends itself to the creation of texture, and this limitless potential can be both fun and challenging. There are lots of ready-made texture pastes and gels available, but you can also use materials such as plastic food wrap, PVA glue, sand, grit, eggshells, etc., to create other exciting effects.

On these pages I show you some of the materials I use to create surface textures. Try out these exercises, then explore ways of solving specific textural problems and expressing yourself in future work.

Sometimes, having created a superb patterned surface, you can conjure a painting around it. Alternatively, the subject matter may dictate a particular theme. However, do restrict yourself to a constructive plan, and try not to overwork textures. Do not keep repeating the same texture just because it works, or you will eventually produce slick and boring pictures. Keep on the move with exploratory splashing, dabbing and impasto effects and you will soon have some unexpected and fabulous results!

Plastic food wrap

Paint a watery but brightly coloured acrylic wash on the paper, then apply a pleated square of plastic food wrap, supporting one side with your fingers and pulling with the other across the wash, so it captures air pockets and forms patterns. Remove the food wrap when the paint is completely dry. This technique is excellent for backgrounds, foregrounds, individual flowers and leaves and many other types of textured surface.

White acrylic impasto

This is one of my favourite texture techniques. Use an old brush or a palette knife and white acrylic to create an impasto study, leave it to dry, then lay wet washes over the surface, allowing some colour to become concentrated in the deep parts of the impasto. This is a superb texture for abstracts, and for weathered wooden surfaces.

Oil pastels

Applying pale-coloured oil pastels under and over an acrylic wash can create some lovely aged and weathered effects. You should also try applying them over a dry acrylic painted surface.

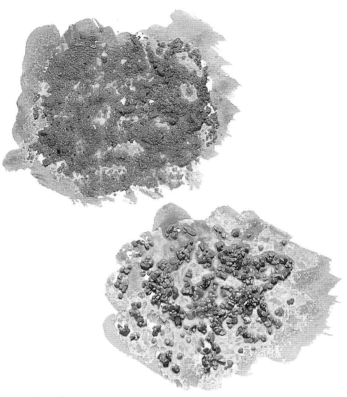

Texture pastes

There are many ready-made texture pastes and gels available for use with acrylic paints. These contain materials such as glass beads, fibres and fine, medium and coarse black grit, and you should experiment with these at your leisure. Apply the paste to the surface, leave it to dry, then paint over the top. This is an example of a coarse sand texture paste, roughened in places to create a rocky effect.

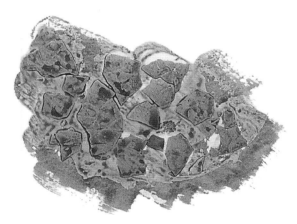

Sand and grit on texture paste

Apply a layer of fine texture paste or gel, or an acrylic medium, on the paper, then sprinkle fine sand or grit on top. Let this dry, then use an old brush to paint over the textured surface; working colour into the open spaces and leaving some of the natural colour of the sand or grit to shine through. The resultant textures are excellent for seaside studies, old walls, gritty footpaths and even some types of foliage. For these two examples, I used fine sand (top) and budgerigar grit, which contains no impurities.

Collage textures

PVA glue can be used to secure found objects – small gems, coloured papers, pencil shavings, eggshells, etc. – on to bare paper to build up collages and some fantastic effects. Acrylic paints and texture pastes also have an amazing adhesive quality and many found objects can be pressed into these. For this example, I used pieces of broken eggshells to create the stone blocks of an old wall, then painted colour over the top. You may need to place a weight (a jam jar full of water) on top of the found objects to hold them in position until the glue is thoroughly dry.

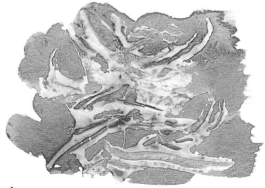

PVA glue

Dribble and swirl PVA glue on the surface of the paper, leave it to dry, then run a wash over the raised surface. This technique can be used to good effect to depict swirling water.

Applying techniques

Having practised the exercises on the previous pages, start to work up small studies such as these. Applying texture techniques effectively involves careful study of the chosen subject and a little imagination. Be prepared to take risks, and you may be surprised at what you can achieve.

Sympathy with the chosen subject is also important, and is one of the factors that make up a successful painting. Choosing an additional ingredient is rather like getting a recipe in cooking correctly proportioned!

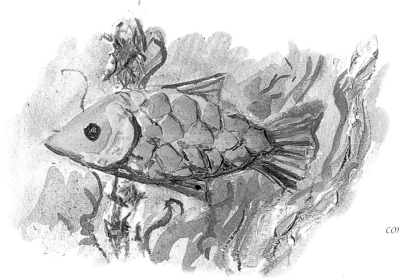

The textures on this fish were created using eggshells, tissue paper, a smooth gel (used as an adhesive), and thick white acrylic paint. I started by outlining the fish with a simple background wash. The eggshells were broken into fish scale shapes then these were stuck down with the smooth gel. White acrylic paint, straight from the tube, was applied with a palette knife to create the weeds at the right-hand side. I crushed some tissue paper into tight folds, then glued this behind the fish's head. I let everything dry thoroughly, then completed the painting using mixes of yellow ochre, cerulean blue and burnt sienna.

This simple seascape, with its dominant rough wave and distant lighthouse, shows the wonderful effects that can be achieved with salt. Apply the salt crystals to wet washes, then watch the chemical reaction take place before your eyes. The results are unpredictable, but you can stop the reaction at any time by drying the paper with a hairdryer. However, do not hold the hairdryer too close to the paper or you will blow the salt away.

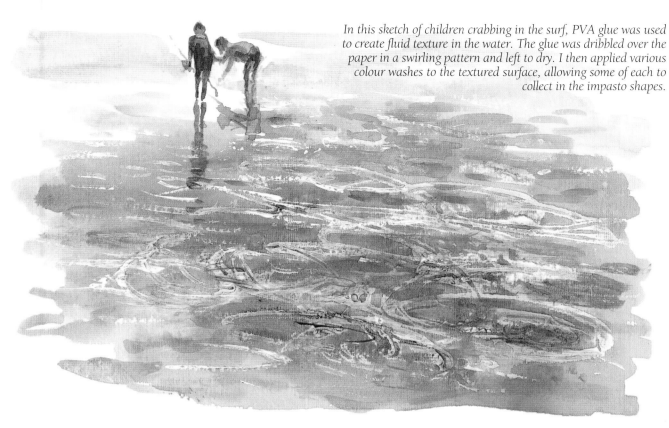

In this sketch of children crabbing in the surf, PVA glue was used to create fluid texture in the water. The glue was dribbled over the paper in a swirling pattern and left to dry. I then applied various colour washes to the textured surface, allowing some of each to collect in the impasto shapes.

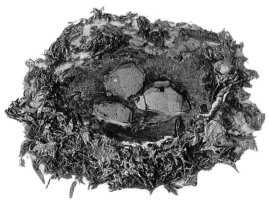

This study is a collage of bits and pieces. I used PVA glue as the base, then pushed in pencil shavings to form the nest shape and broken eggshells for the eggs.

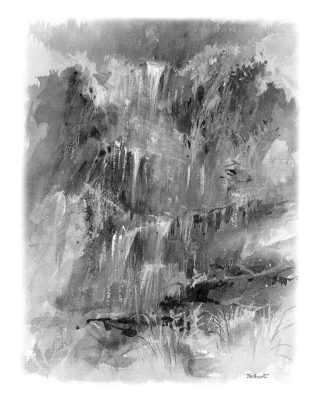

Masking fluid, applied with a ruling pen and an old brush, was used to create the highlights in this waterfall study. I then used thin, watercolour-like washes for the background and thicker paint, applied with both brush and palette knife, for the jagged rocks. This study also involved the mixing a greens which is always an exciting challenge.

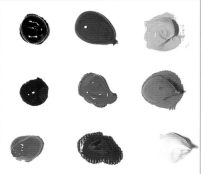

Colours:

Dark olive green, light olive green, cadmium yellow, phthalo blue, cerulean blue, light blue violet, fluorescent pink, burnt sienna and titanium white.

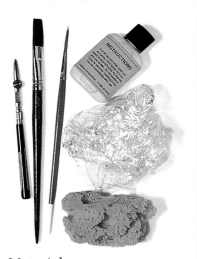

Materials:

Ruling pen, No. 8 flat brush, rigger brush, masking fluid, plastic food wrap, sponge.

Lilac Blooms

I love painting flowers and lilac is one of my favourite subjects. The mass of purple-blue, star-shaped florets creates a wonderful texture and the weighty blooms arch to form interesting shapes. I have therefore chosen lilac as my first subject. This demonstration was painted on a 265 x 370mm (10½ x 14½in) sheet of 300gsm (140lb) Not surface paper. It combines several techniques: laying plastic food wrap on wet washes to create an interesting background; applying masking fluid to create highlights; working wet into wet to develop subtle blended colours; and sponging thick paint to create a random impasto texture.

Lilac was not in season when I painted this demonstration, so I used a few silk blooms for reference.

I find it useful to make detail sketches of various arrangements before making a tonal sketch of the final composition.

Having decided on my composition, I made this tonal sketch as the final reference. I love drawing with aquarelle pencils and here I used a blue one. I sketched the background shapes in light soft tones, then used deeper ones to define the shapes of the foreground blooms and to add the details of the leaves and star-shaped florets.

1. Transfer the outlines of the composition onto the watercolour paper. I normally use an aquarelle pencil, toned to suit the colours of the painting, but for photographic purposes I have used a B pencil.

2. Use the ruling pen and masking fluid to mask out the florets on the flower heads, and the highlights and veins on the leaves. Leave to dry.

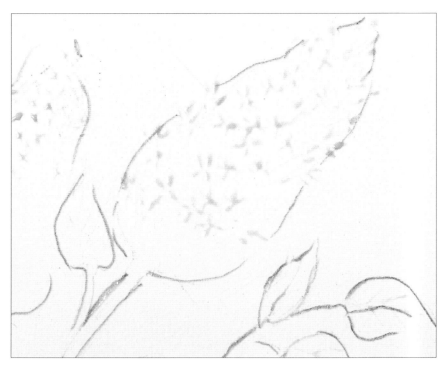

Close up of the masking fluid applied to the flower heads in step 2.

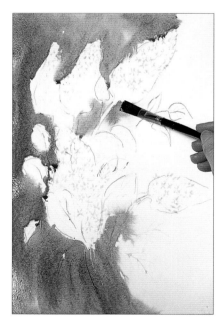

3. Wet the background areas of the paper then lay in a wash of dark olive green mixed with a touch of phthalo blue. Work down the left-hand side first.

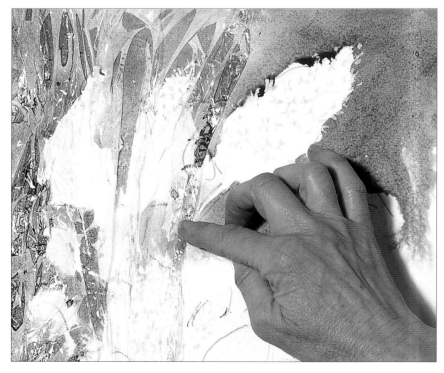

4. Arrange lengths of plastic food wrap on top of the wet paint, then scrunch it slightly to form random patterns.

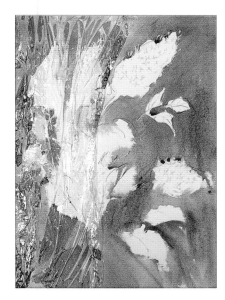

5. Use tones of the previous green mix to paint the rest of the background, then, working wet into wet, drop in a mix of light olive green and cadmium yellow with a touch of burnt sienna.

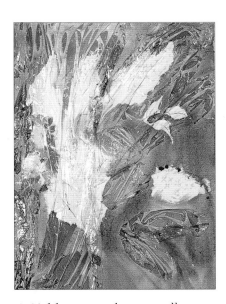

6. Add more cadmium yellow to the pale green mix, then paint the leaves. Place a piece of plastic food wrap on the top right-hand corner of the painting, then add small pieces on the wet leaves.

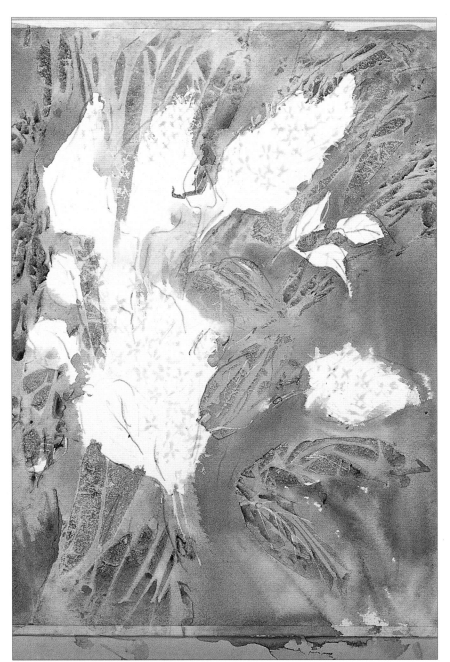

7. Leave the painting to dry, then carefully remove the plastic food wrap. You can speed up the drying process with a hairdryer, but take care not to disturb the plastic food wrap; operate the hairdryer on a low speed setting and hold it well away from the surface of the painting.

8. Mix cadmium yellow with touches of burnt sienna and light olive green, then paint the other leaves in the composition; create darker areas by adding more green to the mix.

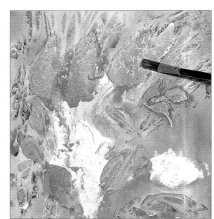

9. Wet the flower heads with clean water, then lay in a wash of light blue violet mixed with cerulean blue. Darken the bottom of each flower head.

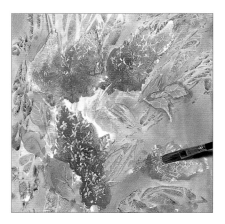

10. Working wet into wet, drop in patches of light blue violet mixed with fluorescent pink. Add touches of cerulean blue at the top of each flower head. Darken the pink mix with phthalo blue, then drop this into the lower parts of the flower heads.

11. Continue applying touches of all the blue mixes to create shape and form.

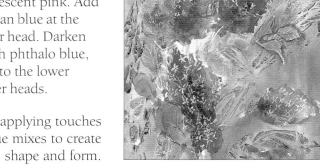

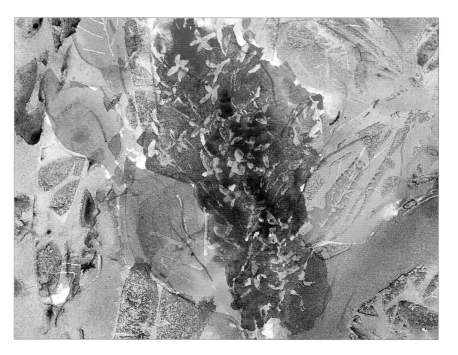

Close up of the bottom flower head showing the subtle shades of blue and pink created in steps 10 and 11.

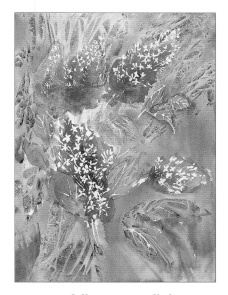

12. Carefully remove all the masking fluid.

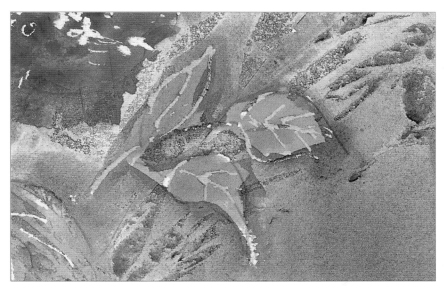

13. Mix a weak, pale green wash (cadmium yellow with pale olive green) then block in the leaves to give tone to their veins. Paint in the leaf between the top flower heads and the one at bottom left.

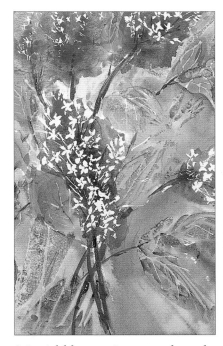

14. Add burnt sienna to the pale green mix, then paint the flower stems. Add touches of this colour to the flower heads to denote the branch structure for the florets in the flower heads.

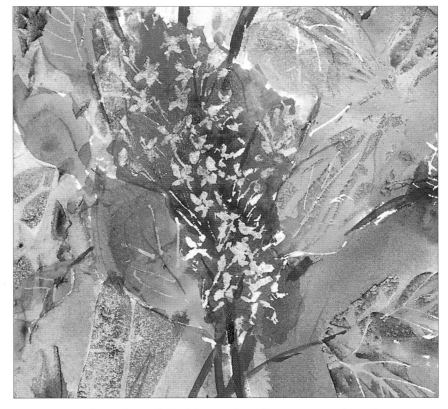

15. Use weak washes of the blue and pink mixes to soften the highlights left by the removal of the masking fluid.

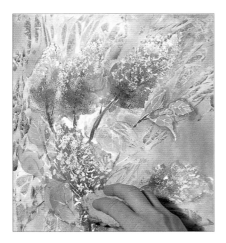

16. Mix titanium white with light blue violet, neat and thick, then use a sponge to dab highlights at the top of the flower heads. Make a slightly wetter mix of phthalo blue and fluorescent pink then dab this on the bottom part of each flower head.

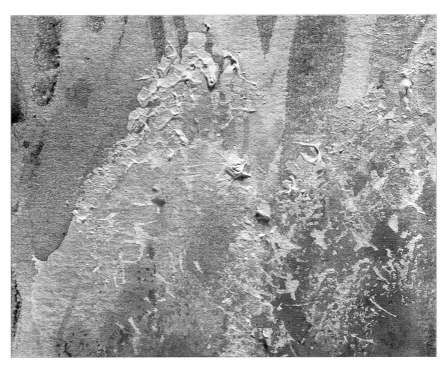

Close up of the top of a flower head showing the sponged texture applied in step 16.

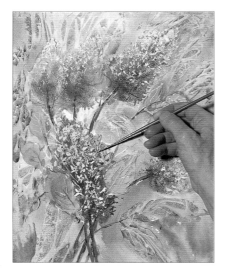

17. Use a rigger brush and the dark blue mix to paint the centre of the florets and buds, to draw in the shapes of the petals of the florets, to create shadows on the stems and to add 'negative' darks that give depth and shape to the flower heads.

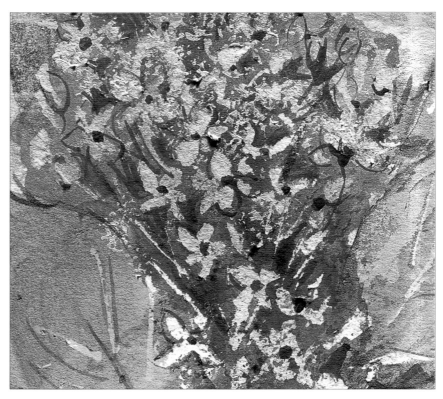

Close up of the bottom flower head showing the details applied in step 17.

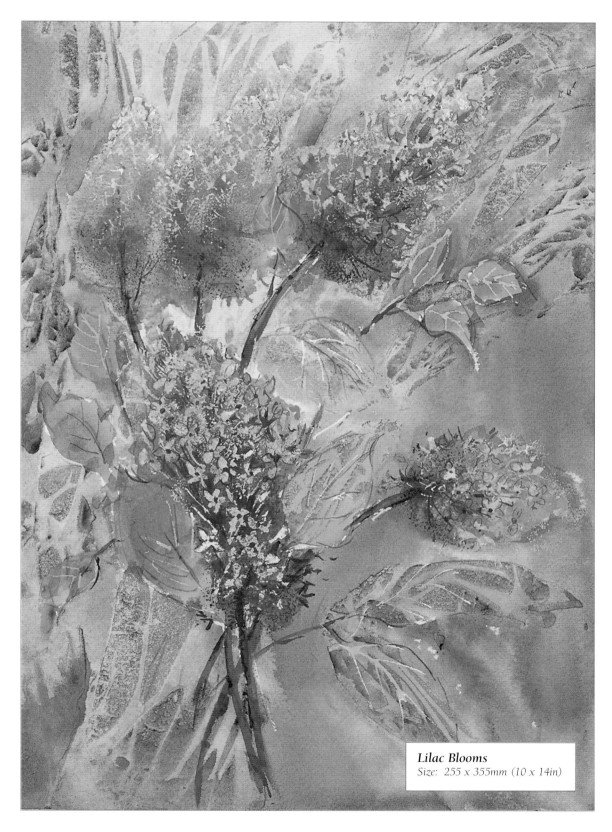

Lilac Blooms
Size: 255 x 355mm (10 x 14in)

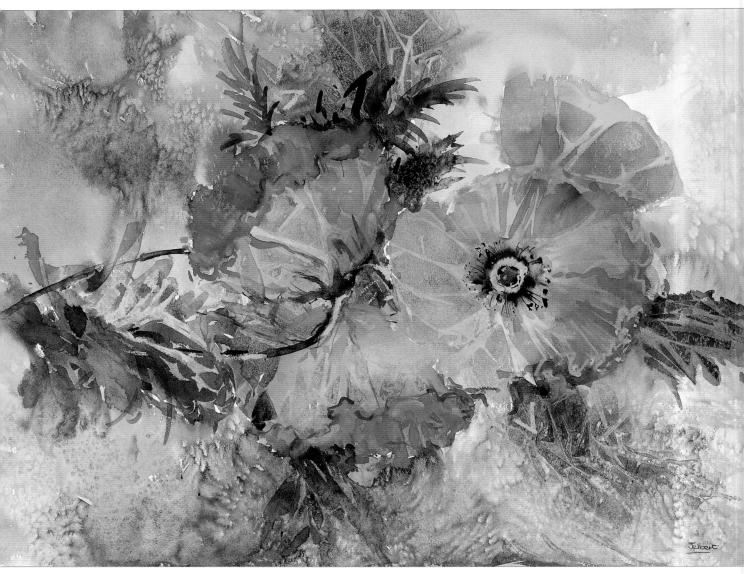

Poppies

Size: 510 x 380mm (20 x 15in)

Poppies are probably the most popular of all flower subjects, but here I have used plastic food wrap to create a completely different interpretation. Experimenting with acrylic techniques is well worth the effort – and often produces unexpected and surprising results.

Opposite

Lilies

Size: 255 x 355mm (10 x 14in)

The amazing effects of using plastic food wrap on acrylic watery washes can be adapted for both flowers and their backgrounds. Here I have used separate strips and squares to create the abstract patterns, petals and leaves. Masking fluid may also be added to the initial drawing for details such as the stamens and stalks. Remember that, when completing the picture, you can always alter the patterns by painting over them.

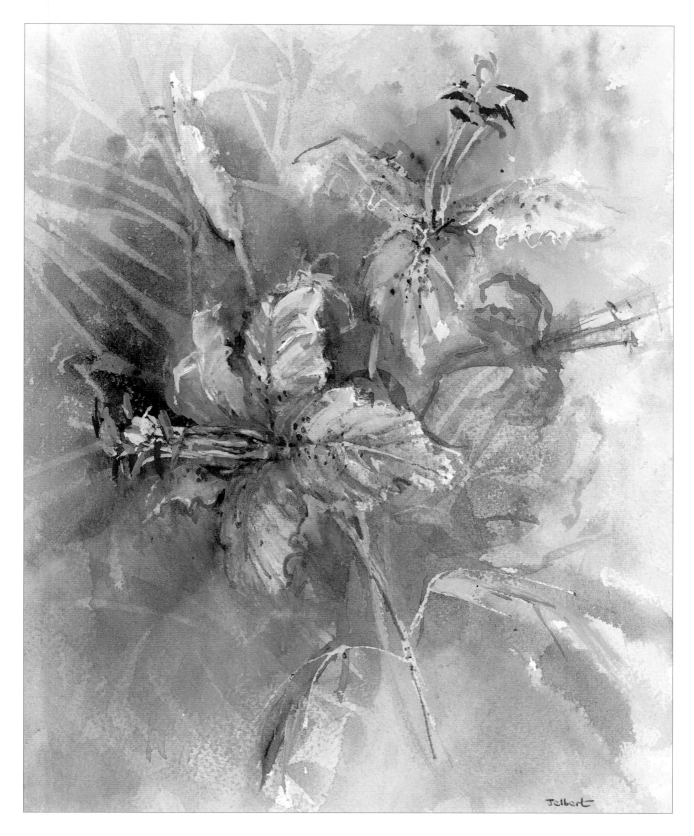

Cornish Hedgerow

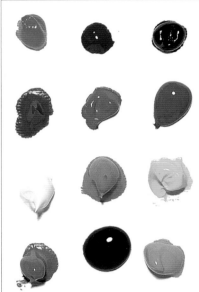

I love organising landscapes, and I often combine elements from a variety of sketches and photographs to create interesting compositions. You do not have to paint exactly what is in front of you; introduce a gate in a wall, or some flowers to create a centre of interest; you could even change the season by adjusting the range of colours used.

The composition for this demonstration is made up from the photographs and sketches shown below. It gives the opportunity to contrast lovely textures in the foreground with soft, muted colours in the background. I painted this picture on a 380 x 280mm (15 x 11in) sheet of 300gsm (140lb) Not surface paper.

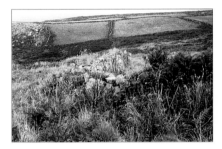
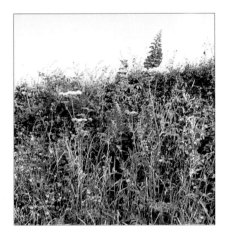

Two of the reference photographs which, in conjunction with my field sketches, were used to develop the composition of this demonstration.

Colours:

Fluorescent pink, phthalo blue, dark olive green, burnt sienna, cerulean blue, light olive green, titanium white, light blue violet, cadmium yellow, neutral grey, dioxazine purple and cadmium orange.

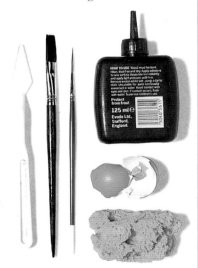

Materials:

Palette knife, No. 8 flat brush, rigger brush, PVA glue, eggshells, sponge.

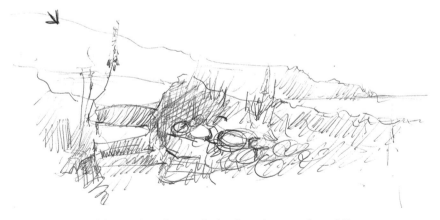

I always find it useful to make a few quick sketches of a scene from different viewpoints. I mark the position of the light source, then roughly block in the shadowed areas. This sketch and the two opposite were drawn with a ballpoint pen.

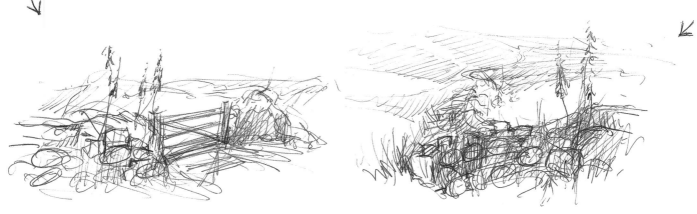

Moving things about and adding different features to a composition can be quite exciting. These three sketches were all drawn at the same scene and they all include the stone wall that first took my eye. However, by changing the viewpoint slightly, and adding elements from the vicinity, you can create a series of compositions from one location.

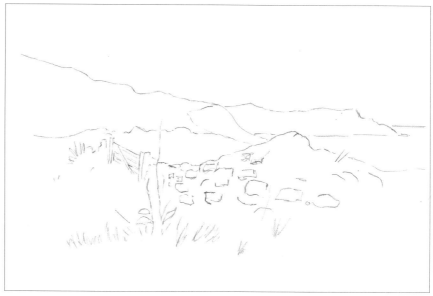

1. When you are happy with the composition, transfer the outlines on to the watercolour paper.

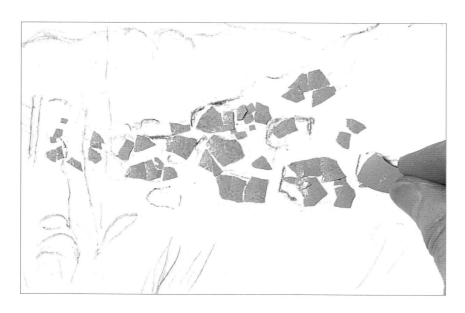

2. Break the eggshells into pieces that resemble the drawn rocks in the sketch, then use PVA glue to stick these on to the paper.

3. Mix a wash of cadmium orange, then sponge an undercoat of this all over the sheet of paper. Leave to dry.

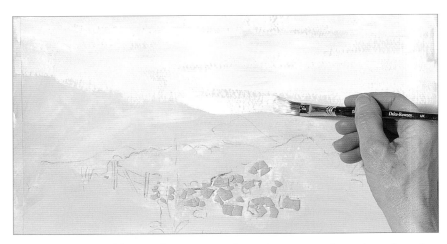

4. Mix cerulean blue and titanium white then, using broad strokes, lay in the sky; leave some speckles of orange showing through the blue.

5. Mix a touch of cadmium orange with cerulean blue then block in the area of sea.

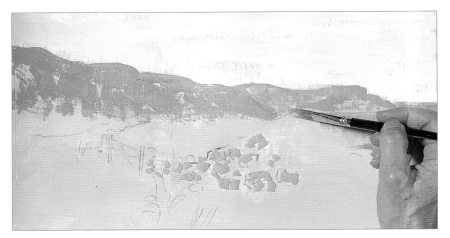

6. Use a mix of light olive green and light blue violet to paint the hills at the left-hand side, leaving some of the under-glaze showing through. Add a touch of titanium white, then block in the distant hills.

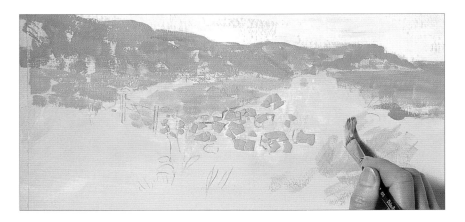

7. Mix light olive green with cadmium yellow and titanium white, then dab strokes of colour into the fields beyond the wall and into the right-hand side of the foreground.

8. Mix a violet from cerulean blue and fluorescent pink, then paint the dark parts of the distant and foreground walls. Weaken the mix slightly, then add some textural marks in the foreground. Use this same mix to start to define shape and form in the foreground wall.

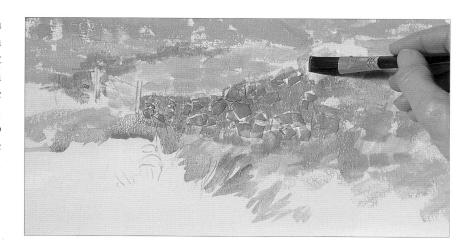

9. Use phthalo blue and light olive green to mix a bright bluish green, then roughly block in the foliage on the wall and in the foreground. Vary the tone to create shape and form.

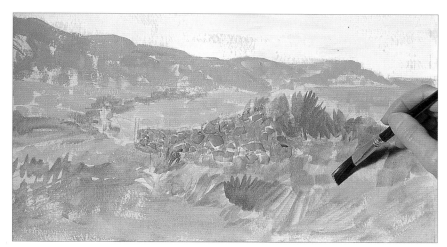

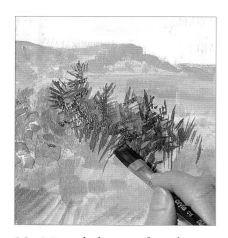

10. Mix a dark green from burnt sienna and phthalo blue, then start to add detail to the foliage and ferns on top of the wall.

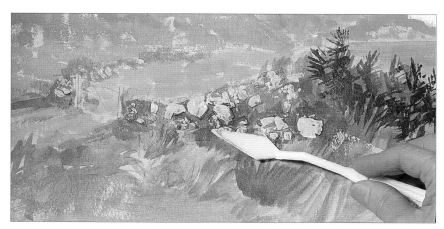

11. Make a thick mix of titanium white, neutral grey and a touch of cerulean blue, then use a palette knife to drag this colour over the eggshells on the wall. Dab spots of this colour on the distant wall.

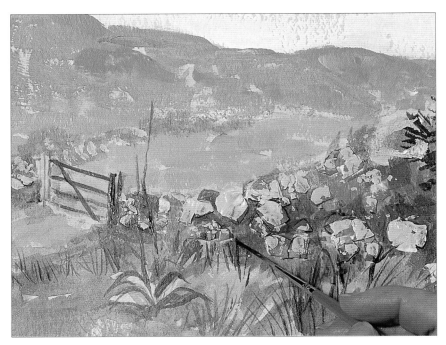

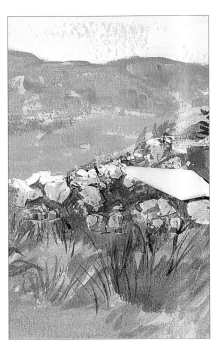

12. Use a rigger brush with a mix of burnt sienna and phthalo blue to paint the gate. Mix a mid-green colour, from dark and light olive green, then 'draw' in the skeletal structure of the wild flowers and the foreground grasses. Mix dioxazine purple and burnt sienna, then add more darks between the stones in the wall and all over the painting to indicate shadows and form.

13. Use titanium white with touches of neutral grey and cadmium yellow and a palette knife to add highlights to the top of the wall.

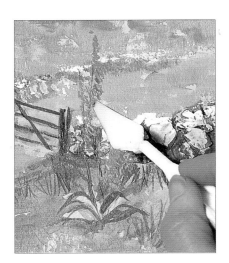

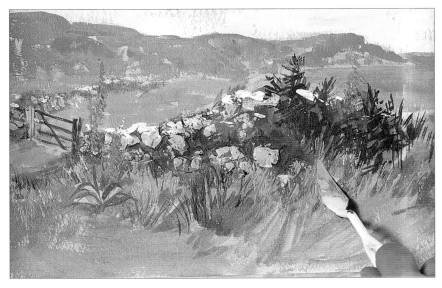

14. Mix cadmium orange and fluorescent pink with a tiny touch of titanium white, then use the tip of the palette knife to create the spikes of wild flowers.

15. Mix cadmium yellow and light olive green then use the edge of the palette knife to lay in the grasses across the foreground. Use the tip of the knife to scratch back through the applied colour. Leave to dry.

16. Mix burnt sienna with dioxazine purple then spatter darks over the foreground area.

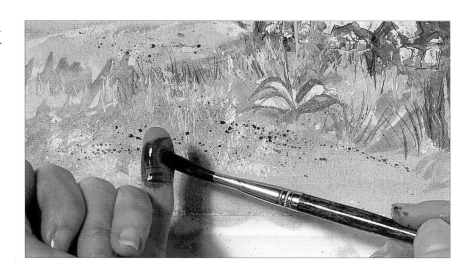

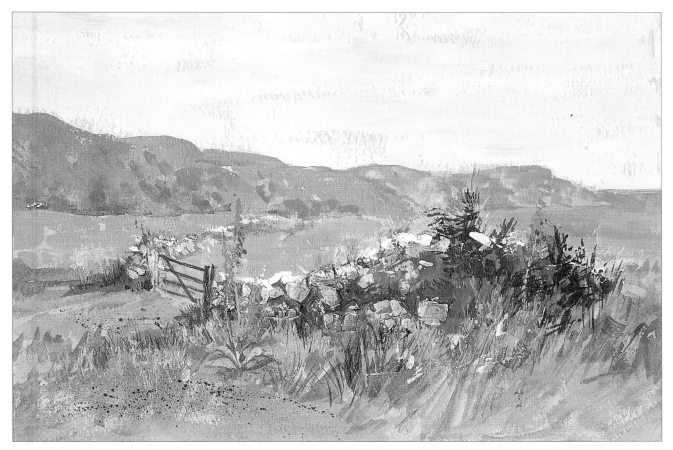

Cornish Hedgerow
Size: 360 x 265mm (14¼ x 10½in)

At the end of step 16, I stood back and had a look at the painting. I decided to bring the foreground forward by laying a light blue violet wash over the hills. I also added touches of this colour randomly on the walls. Finally, I added touches of darks to emphasise shape and form, and touches of cadmium orange here and there in the foreground to add warmth.

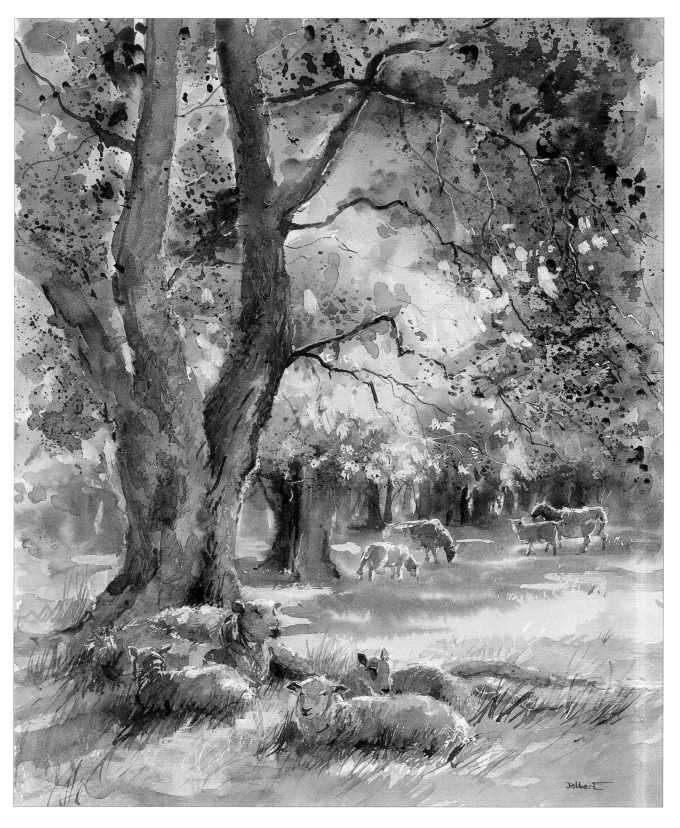

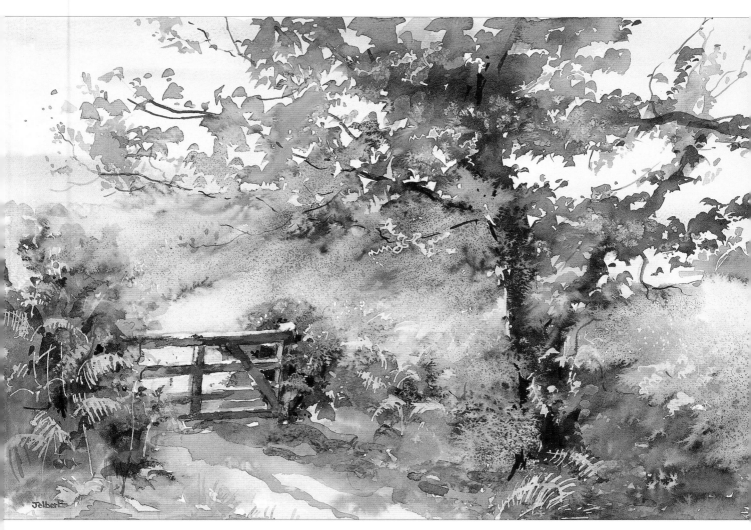

Summer Country Lane

Size: 405 x 305mm (16 x 12in)

This delightful scene gave me the perfect excuse to use salt. I used masking fluid to create highlights before applying a series of green washes over the background areas. I then sprinkled salt on to the wet paper and waited for it to work up this soft, misty quality.

When the salt had been rubbed off the paper, I used a dark olive green to define the shaded foliage around the gate and trees, then contrasted this with yellows and pale greens to create a sunny glow.

Opposite

Sheep in Autumn Sunlight

Size: 405 x 510mm (16 x 20in)

This composition has a gorgeous contrast between the bright, vibrant tones of sunlight and the pools of dappled shade in which we discover the groups of sheep painted in dark tones of violet blue. I used the spattering technique to accentuate some of the foliage.

Colours:

Cerulean blue, phthalo blue, yellow ochre, burnt sienna and titanium white.

Materials:

Ruling pen, palette knife, No. 8 flat brush, rigger brush, PVA glue, masking fluid, texture paste.

Seascape

I decided to include a seascape as my final demonstration because water and rocks provide an abundant source of textures, shapes, tones and colours. This composition, which includes swirling water, crashing waves and spray-soaked rocks, allows me to combine brush and palette knife work with masking fluid, texture pastes, PVA glue and acrylics in one painting. I painted this demonstration on a 405 x 305mm (16 x 12in) sheet of 300gsm (140lb) Not surface paper.

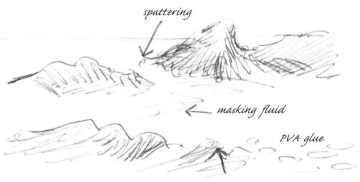

spattering

masking fluid

PVA glue

texture paste

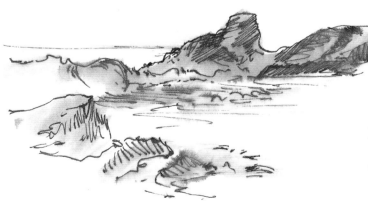

I made various sketches of this subject, moving things around until I was happy with the composition. I annotated the final pencil sketch with notes about the texture techniques I wanted to use, then, to complete my reference material, I made this quick colourwash tonal sketch.

1. Sketch the basic outlines of the final composition on to the watercolour paper.

2. Use a palette knife to apply texture paste quite thickly to the foreground rocks, and slightly less thick on the distant ones.

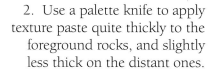

Close up showing the texture paste applied to the foreground in step 2.

3. Working from the nozzle on the bottle of PVA glue, apply swirls of glue across the foreground area of the sea.

4. Use the tip of the palette knife to move the PVA glue into finer swirls. Leave to dry.

5. Use the ruling pen to apply masking fluid to the top of the breaking wave and along the tops of the distant rocks.

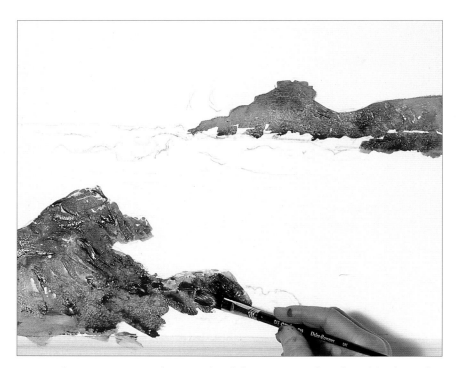

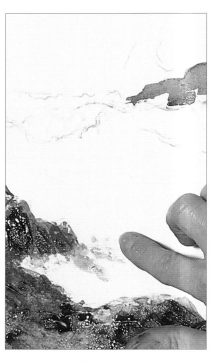

6. Mix burnt sienna with a touch of dioxazine violet, then block in the rocks in the distance and those in the foreground. Add a touch of phthalo blue to the mix in the foreground. Use bold random strokes to create shape and form. Leave some speckles of white paper.

7. Use your finger to soften the hard edges of the rocks where they meet the water, then leave the paint to dry slightly.

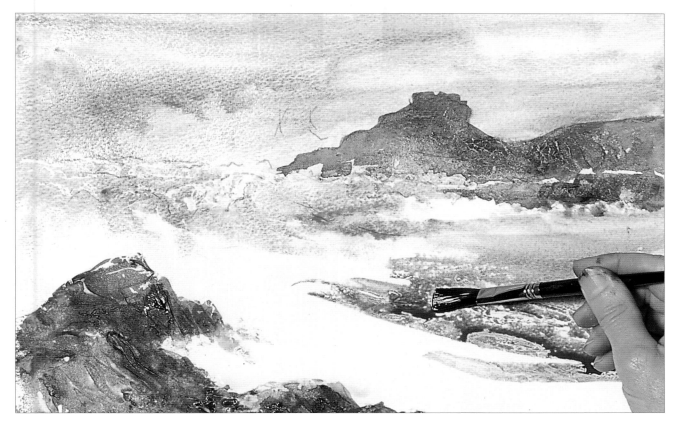

8. While the rocks are still damp, wet the rest of the white paper, then use a wash of cerulean blue with a touch of burnt sienna to paint the sky. Mix a wash of phthalo blue with touches of cerulean blue and burnt sienna and paint the sea.

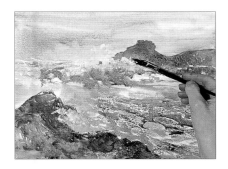

9. Use tones of the two blues to build up shape and form in the sky and sea. Spatter titanium white (see page 37) to create spray on the distant headland.

10. Use the same mix to spatter foam on the foreground rocks.

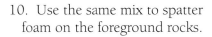

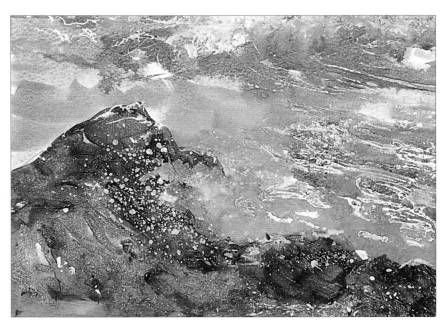

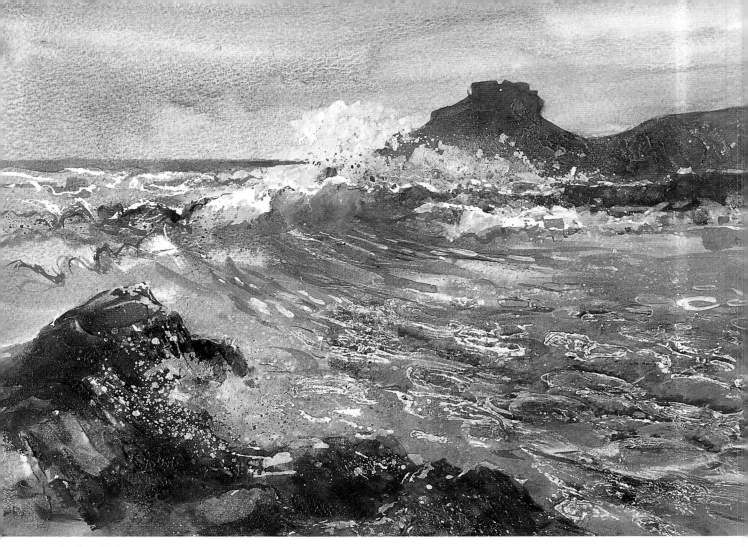

The finished painting

Size: 360 x 260mm (14¼ x 10¼in)

I removed the masking fluid, then used a rigger brush to add dark accents of colour to develop shape and form. I used the dark blue mix to emphasise the large wave in the centre of the painting. I spattered some darks on the breaking waves to create a contrast with the white spray. Finally, I softened some of the white area exposed by removing the masking fluid with a weak wash of yellow ochre.

Close up of the foreground showing the effect of texture paste.

Close up of foreground sea showing the effect of PVA glue.

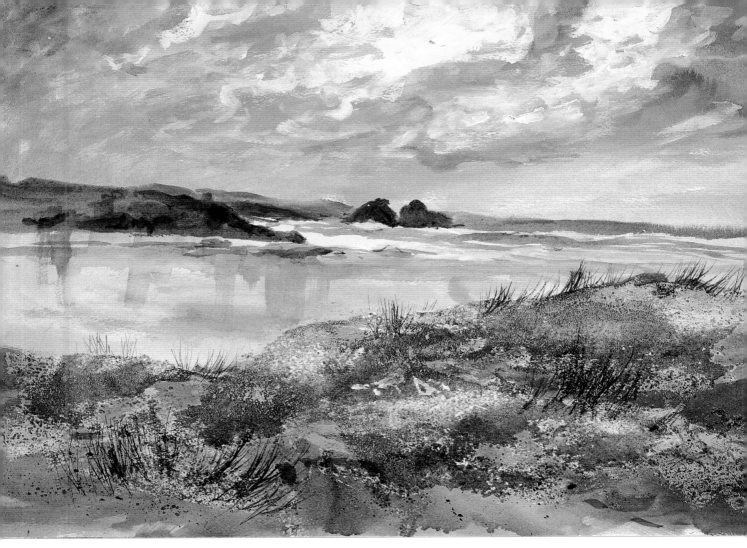

Low Tide
Size: 460 x 330mm (18 x 13in)

This heavily textured foreground was built up with a gritty texture paste and an apricot undercoat was applied all over the paper. The painting was then rendered with a combination of thick paint applied with a palette knife and watery washes applied with a brush.

The Boat Race

Size: 510 x 405mm (20 x 16in)

This composition uses scale, texture and detail to impart a dramatic sense of space and distance. The foreground grasses are large and the sandy areas are heavily textured. The figures in the middle distance, which are relatively smaller and less detailed, give the viewer a general idea of scale. Then, in the far distance, the boats are defined by simple triangular marks set at interesting angles against the far shoreline.

I started this painting by using a rag to rub an orange undercoat across all the paper. I used acrylics as oils to paint in the sky, then the wet-into-wet technique to create the soft distant headland. In the foreground, I applied thick paint with a palette knife to add light and sparkle to the dunes.

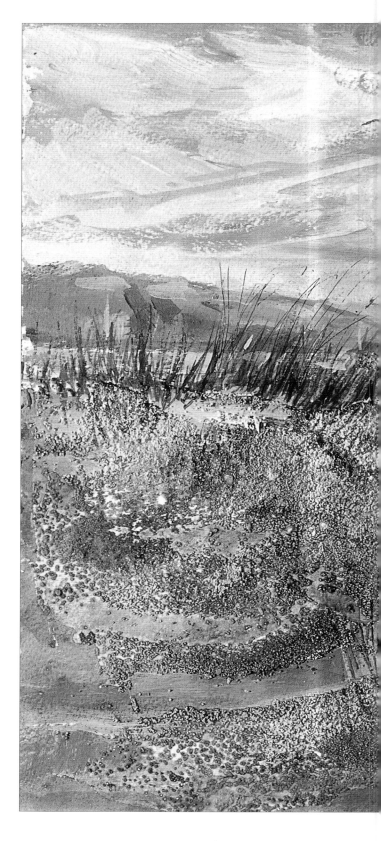

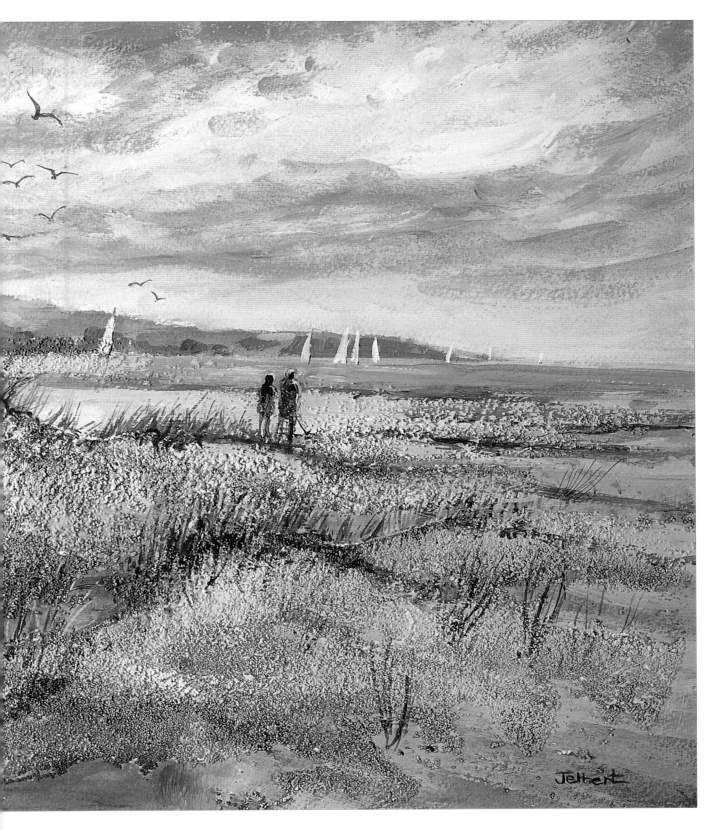

Index

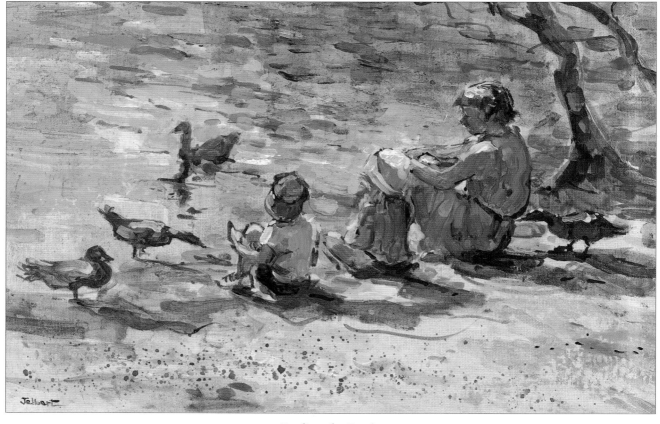

Feeding the Ducks
Size: 305 x 380mm (12 x 15in)

This intimate and delightful family group caught my eye and I stopped to sketch the scene. Back home in my studio, I painted it using oil techniques with both palette knife and brush. The detail is rendered quite loosely over an undercoat of burnt sienna.